Zero Fucks Given

Swear and Relax

Vulgar Word Coloring Book

for

Ranting and Relaxing

S.B. Nozaz

Copyright © 2016 by S.B. Nozaz

All rights reserved worldwide. No part of this publication may be reproduced or distributed in any form or by any means, mechanical, electronic or stored in a retrieval or database system, without written permission from the copyright holder.

Happy Coloring!

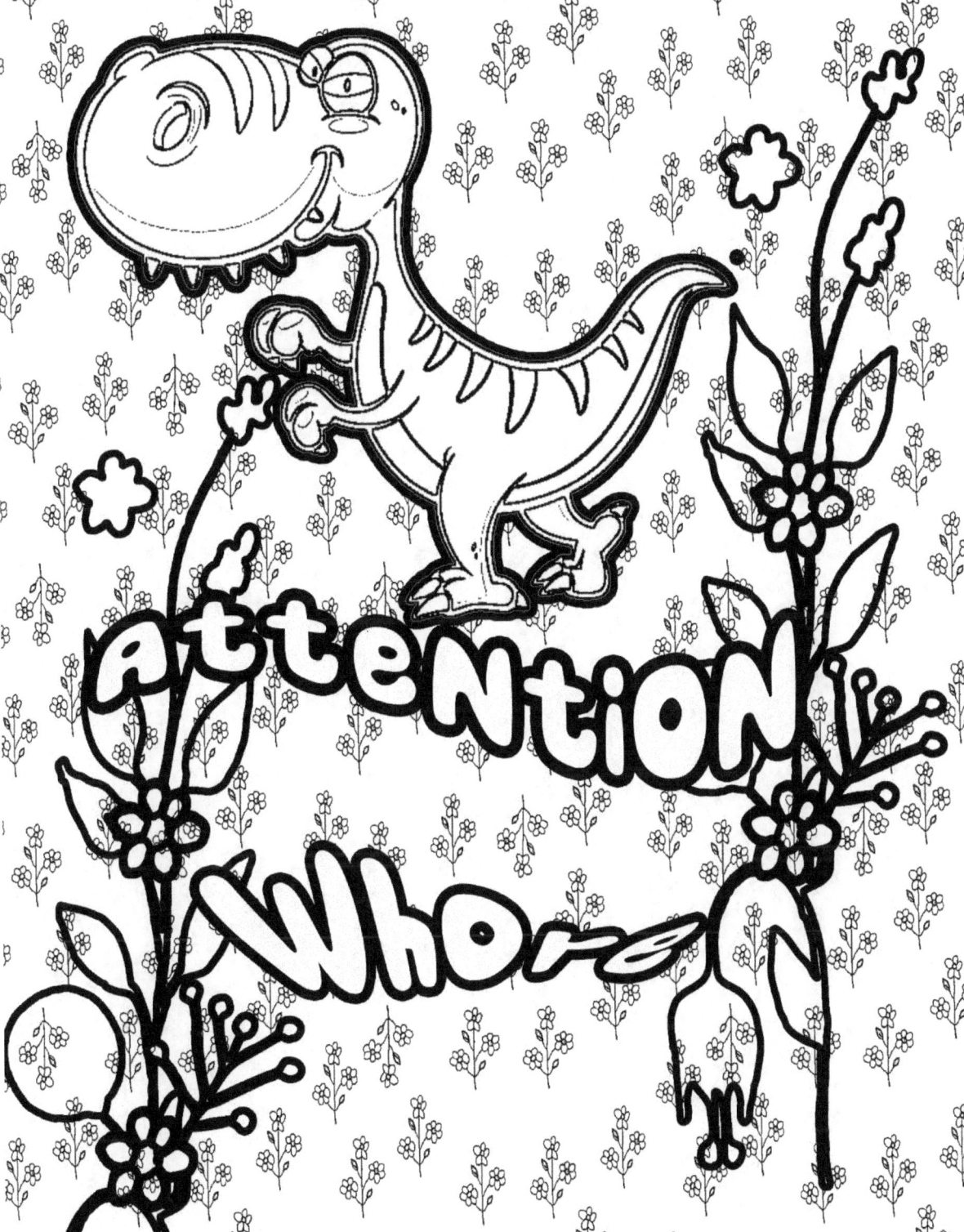

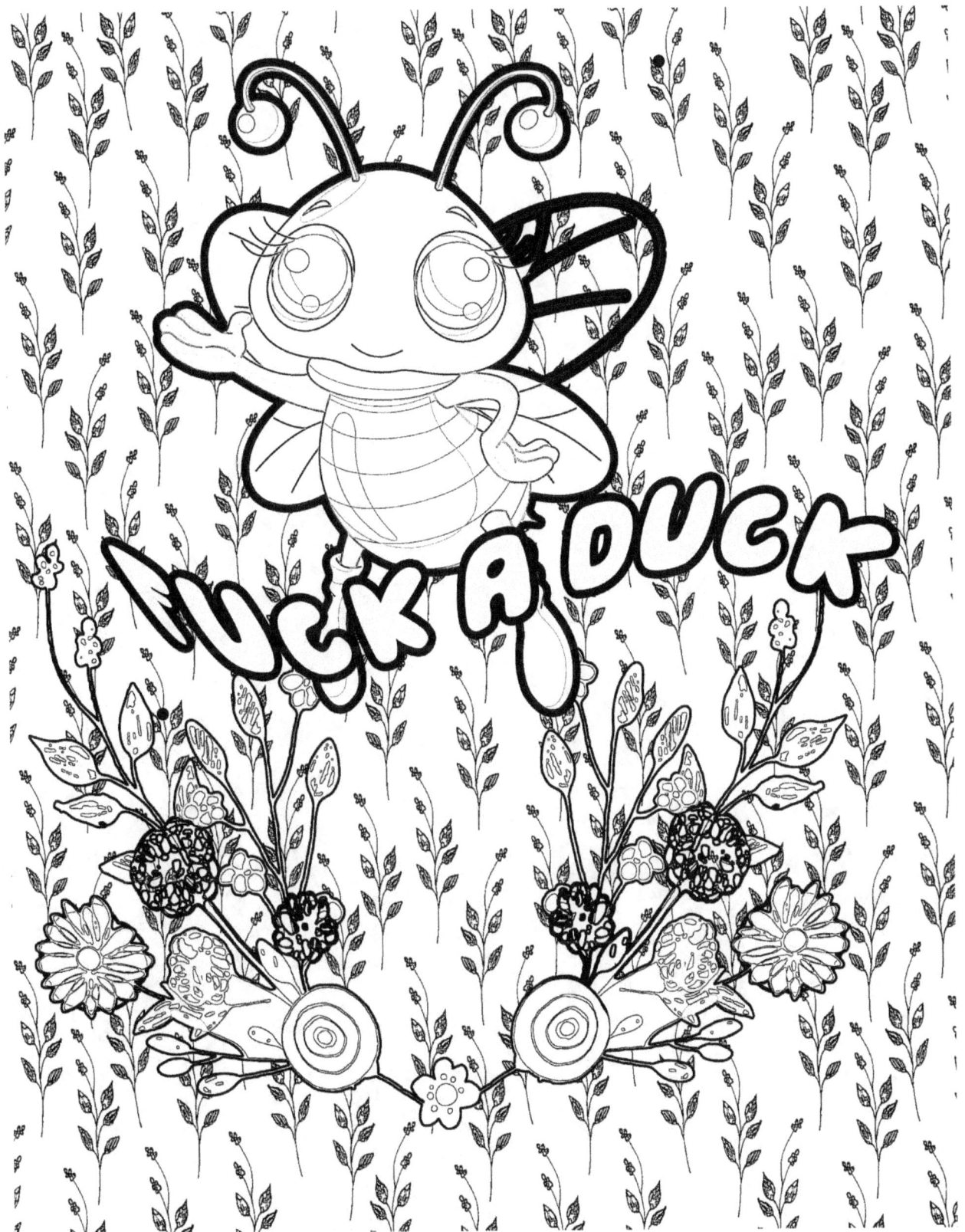

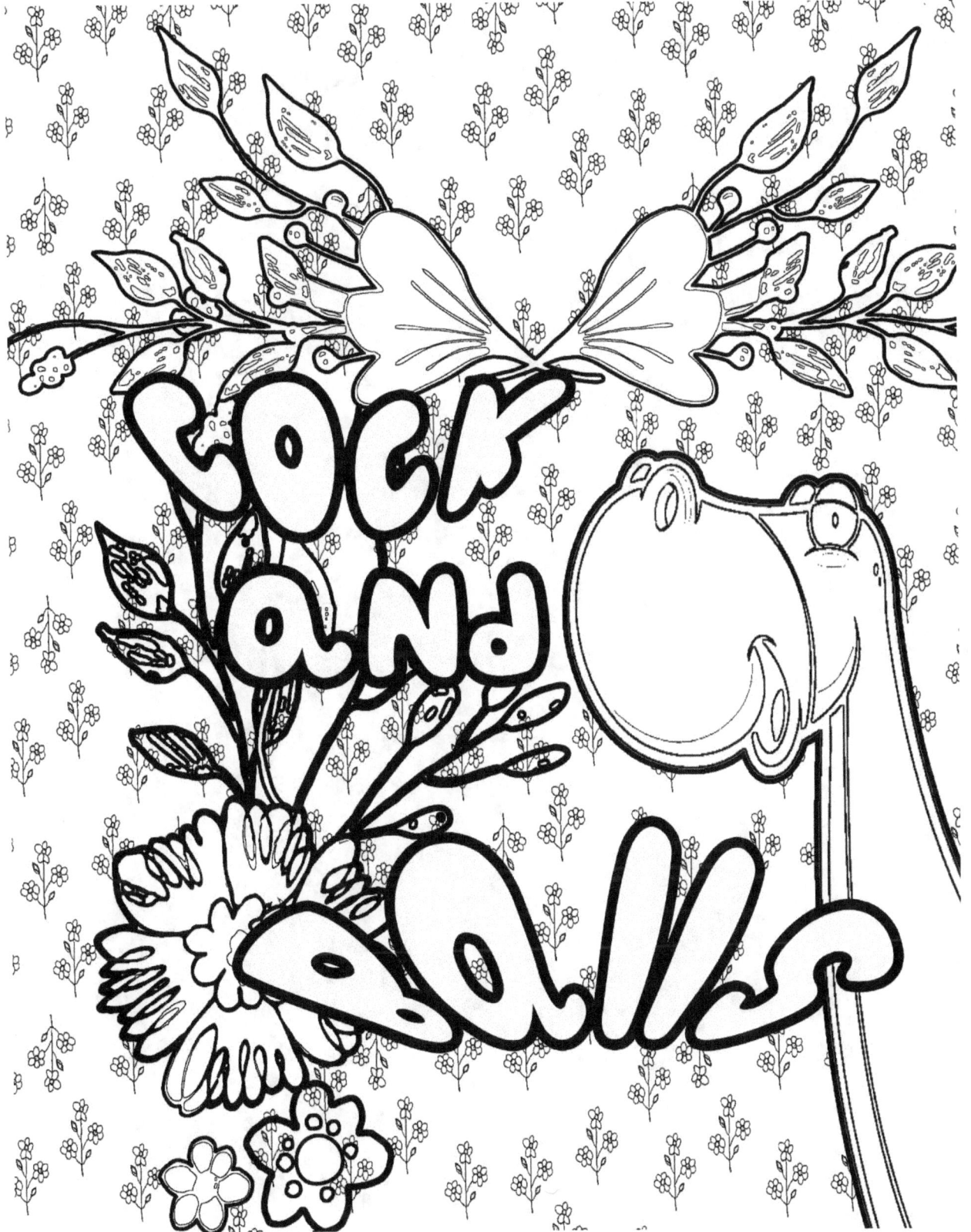

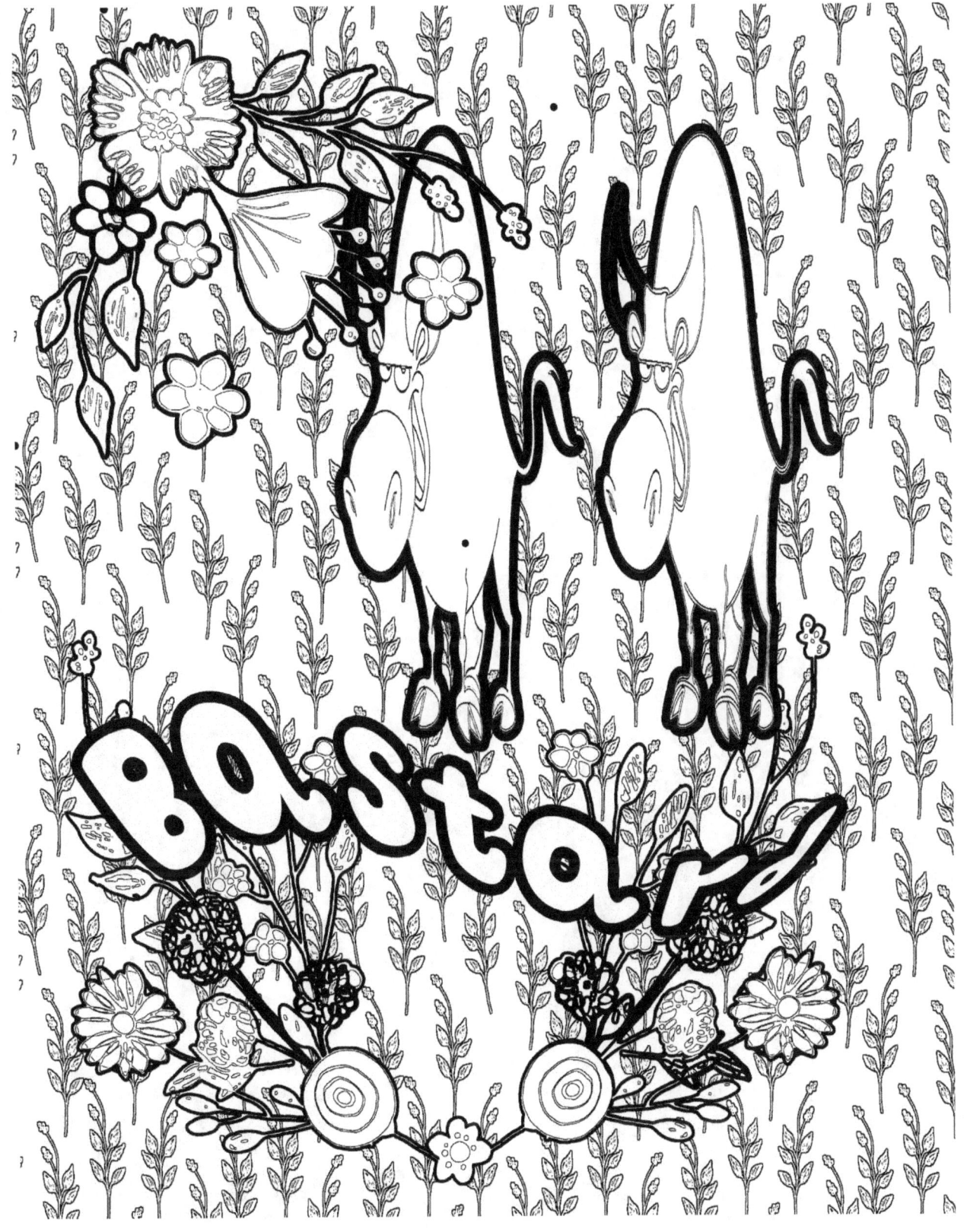

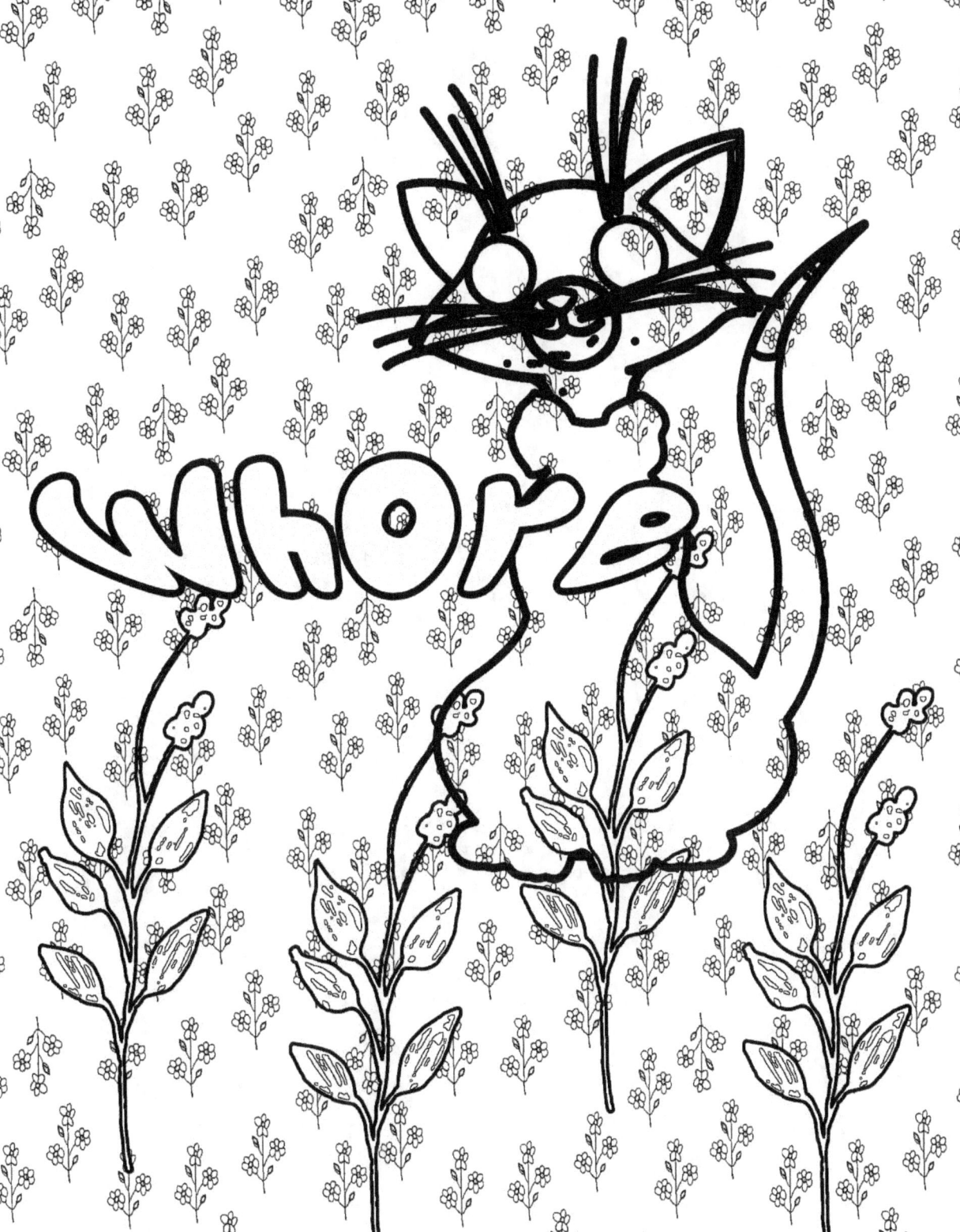

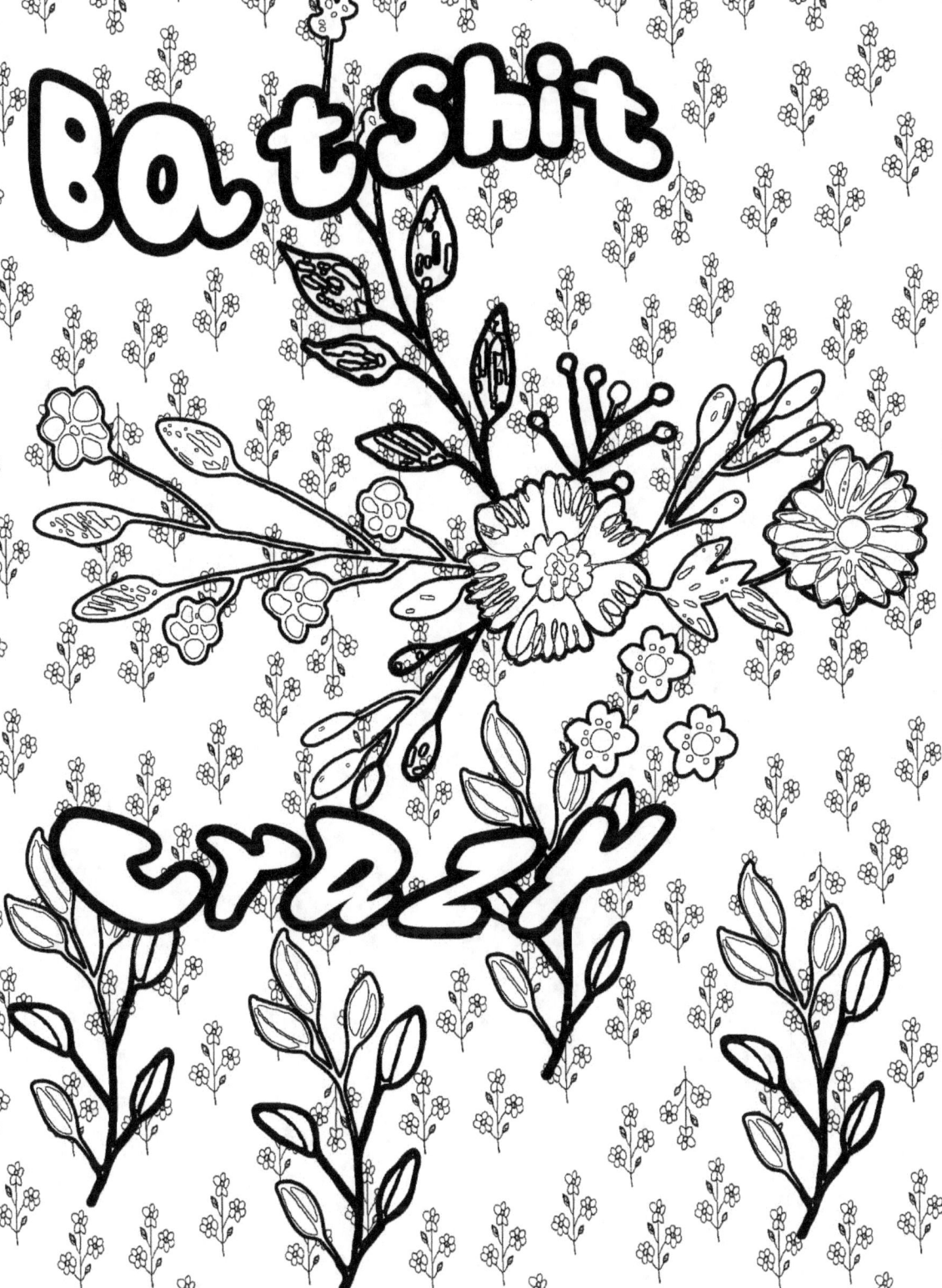

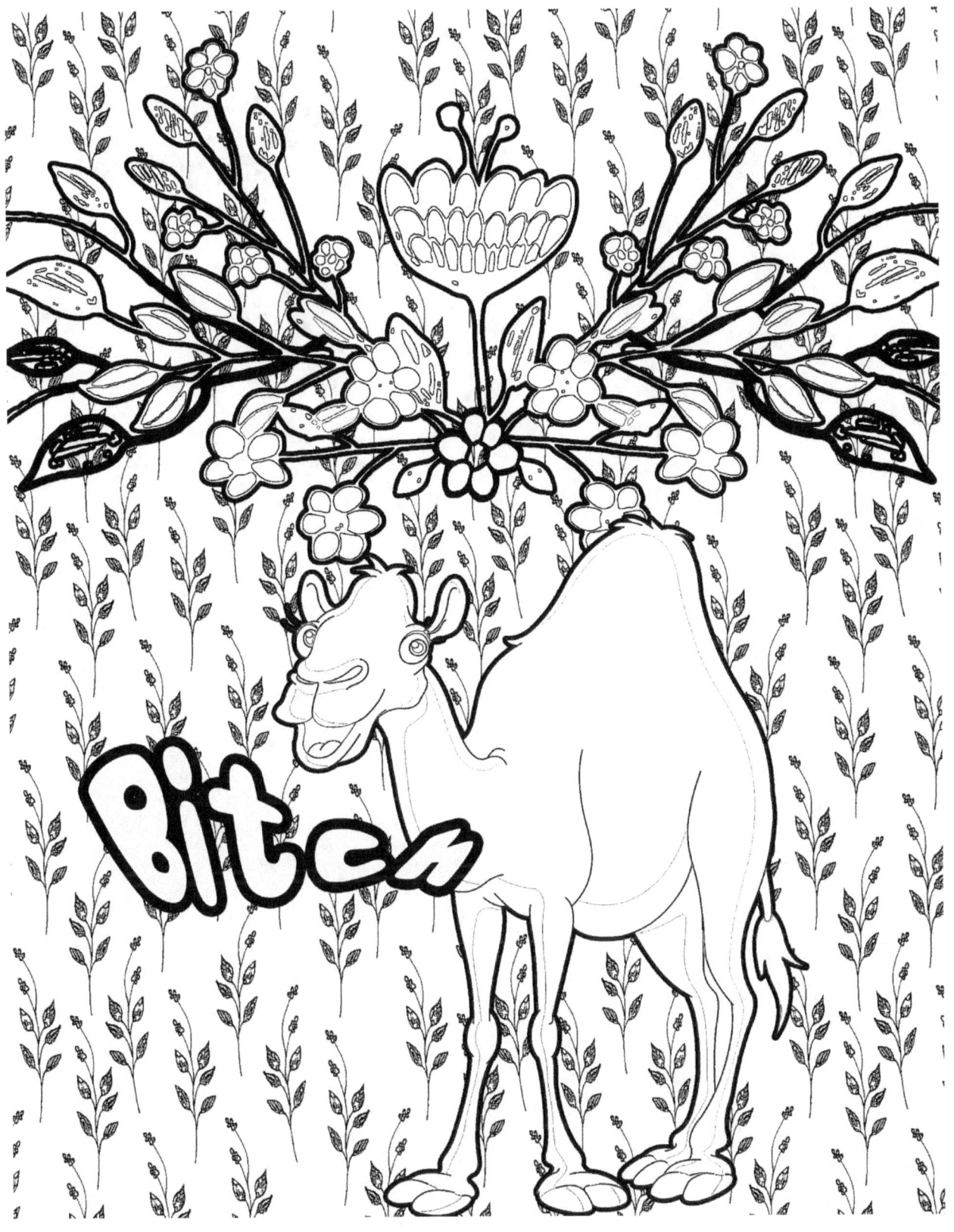

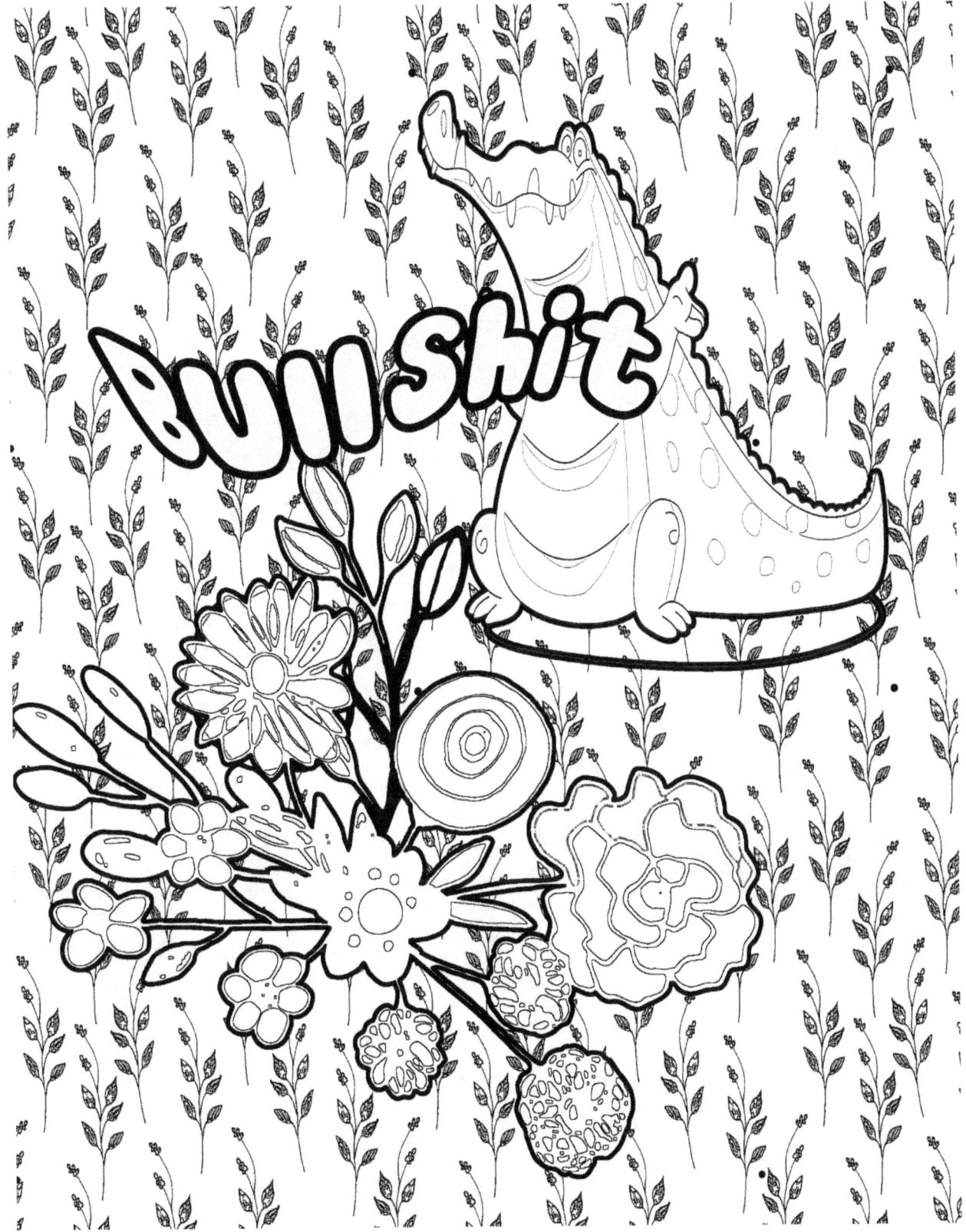

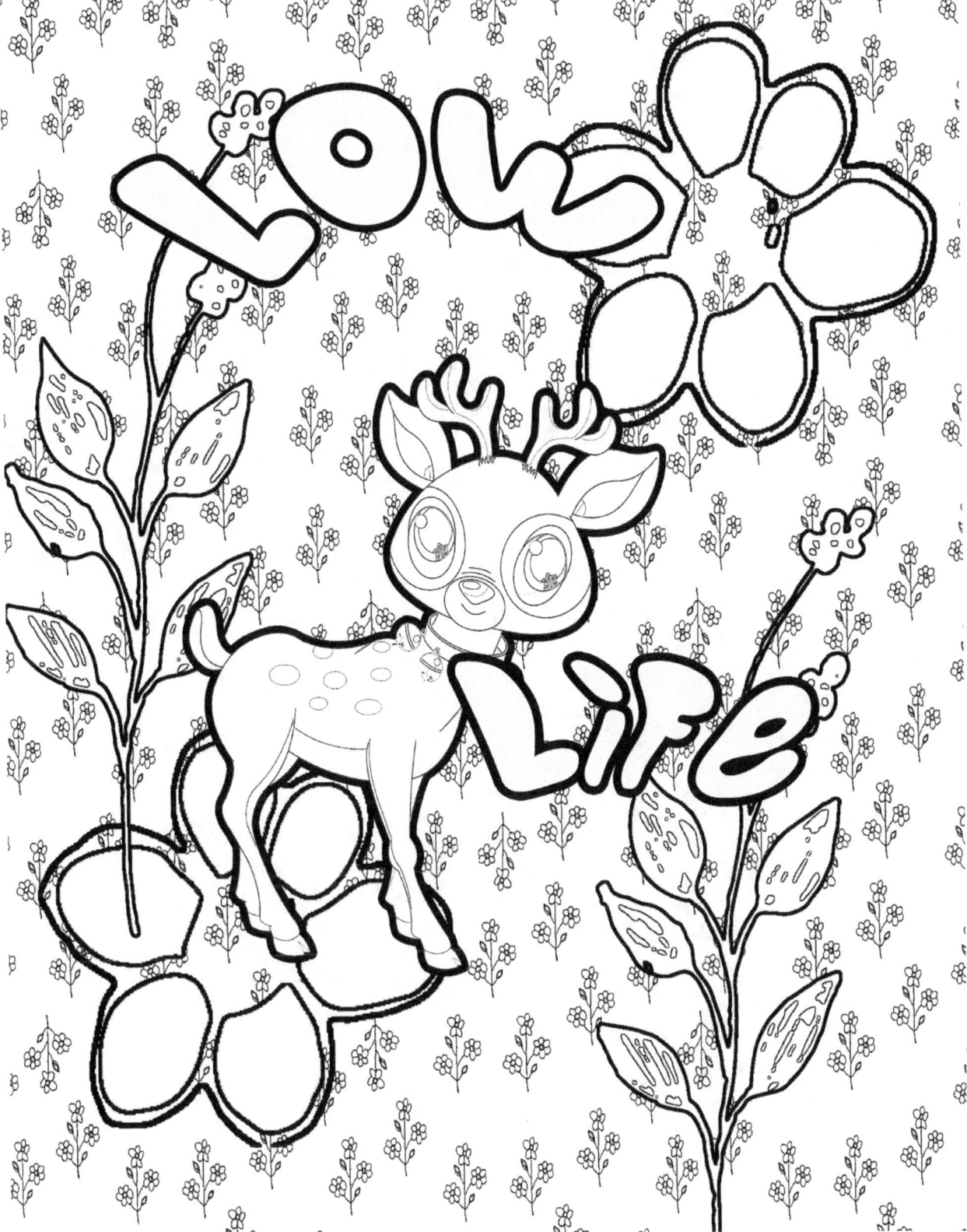

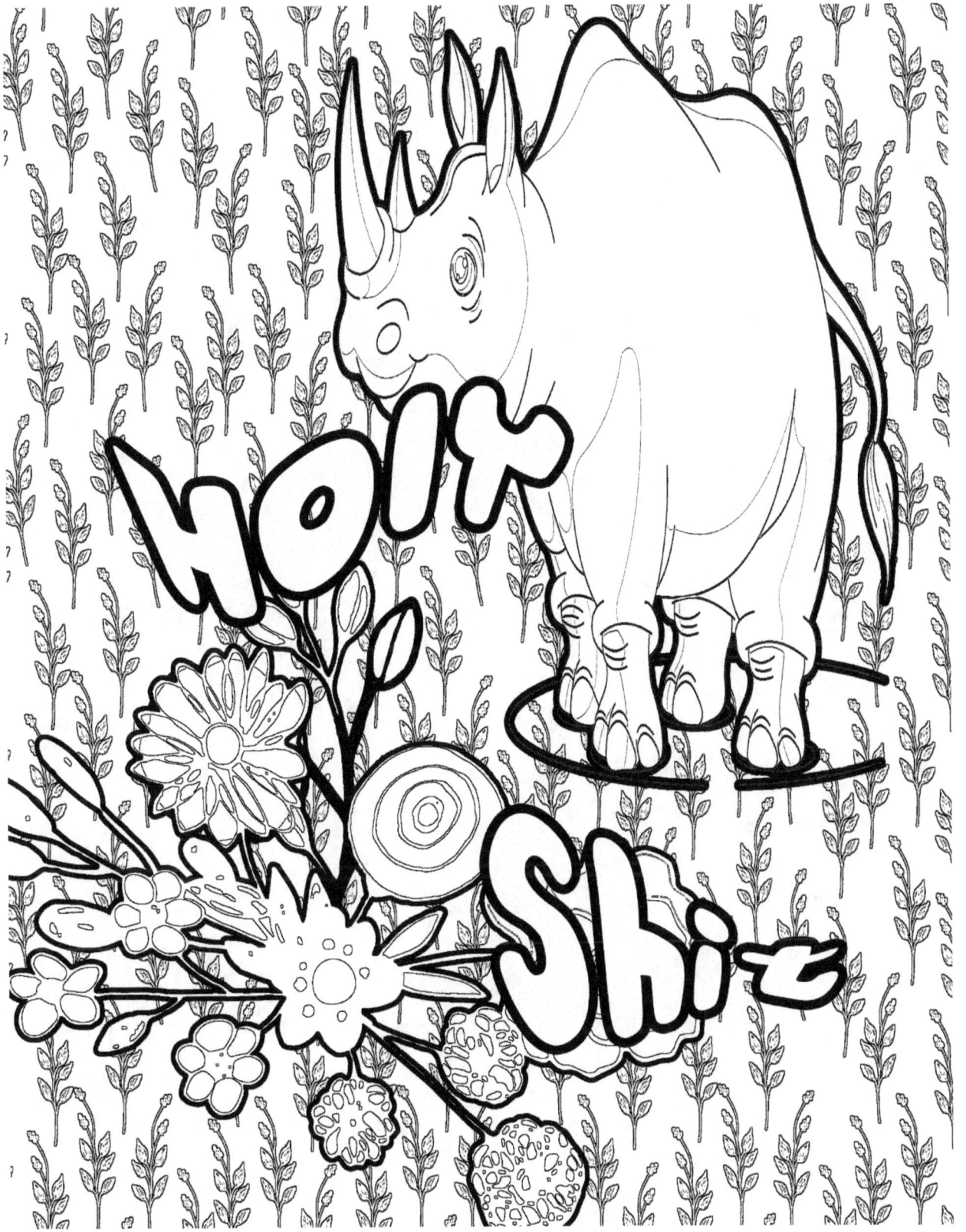

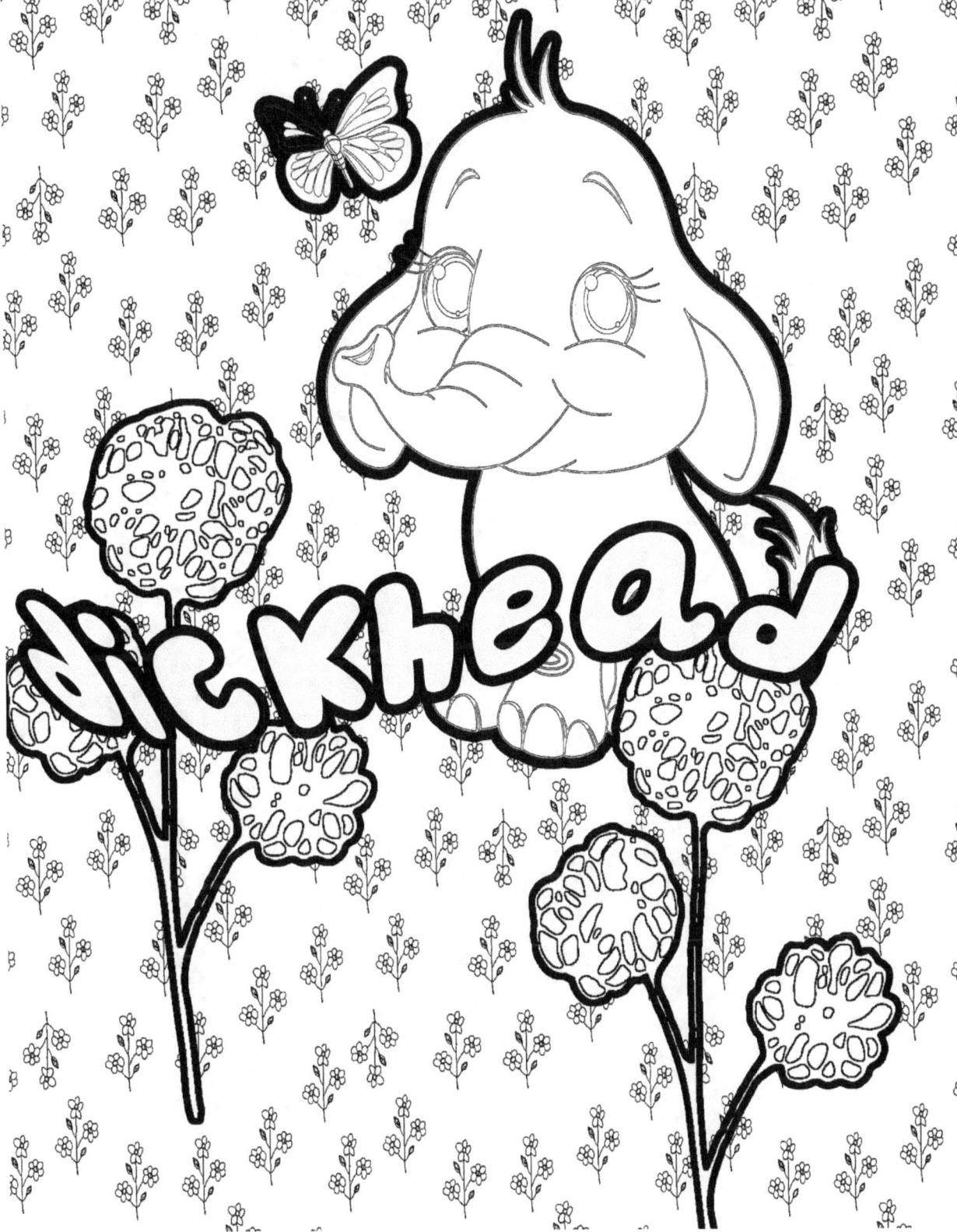

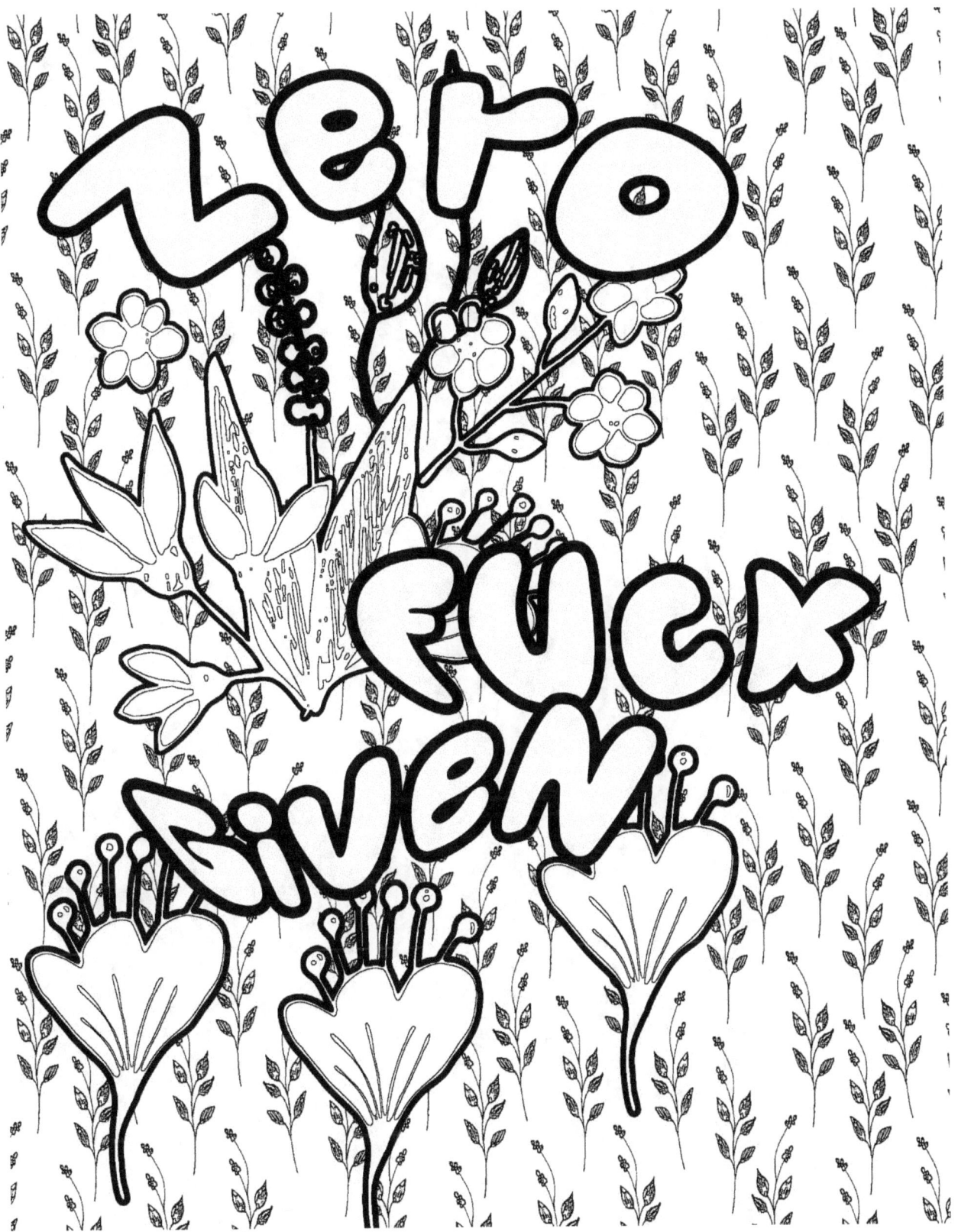

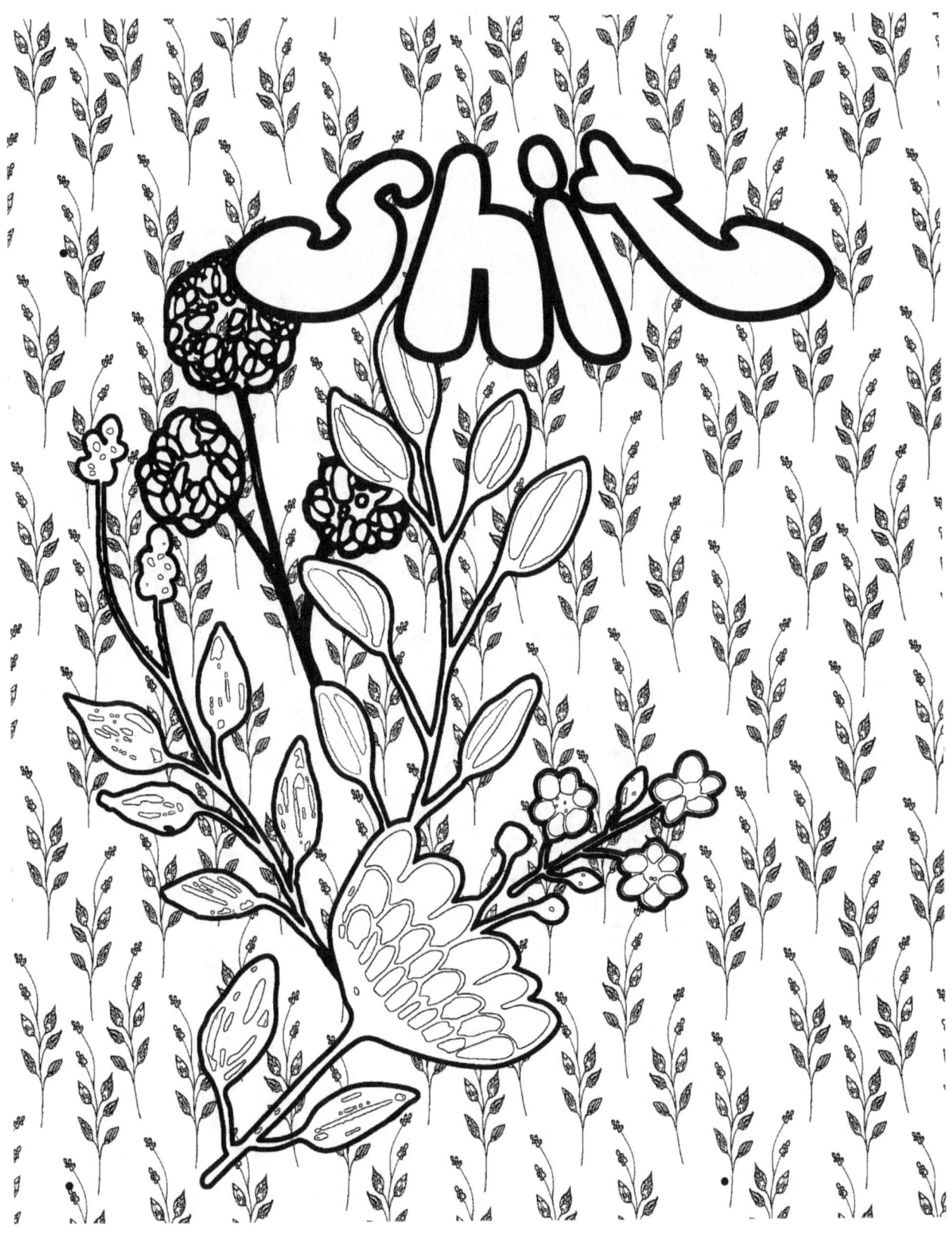

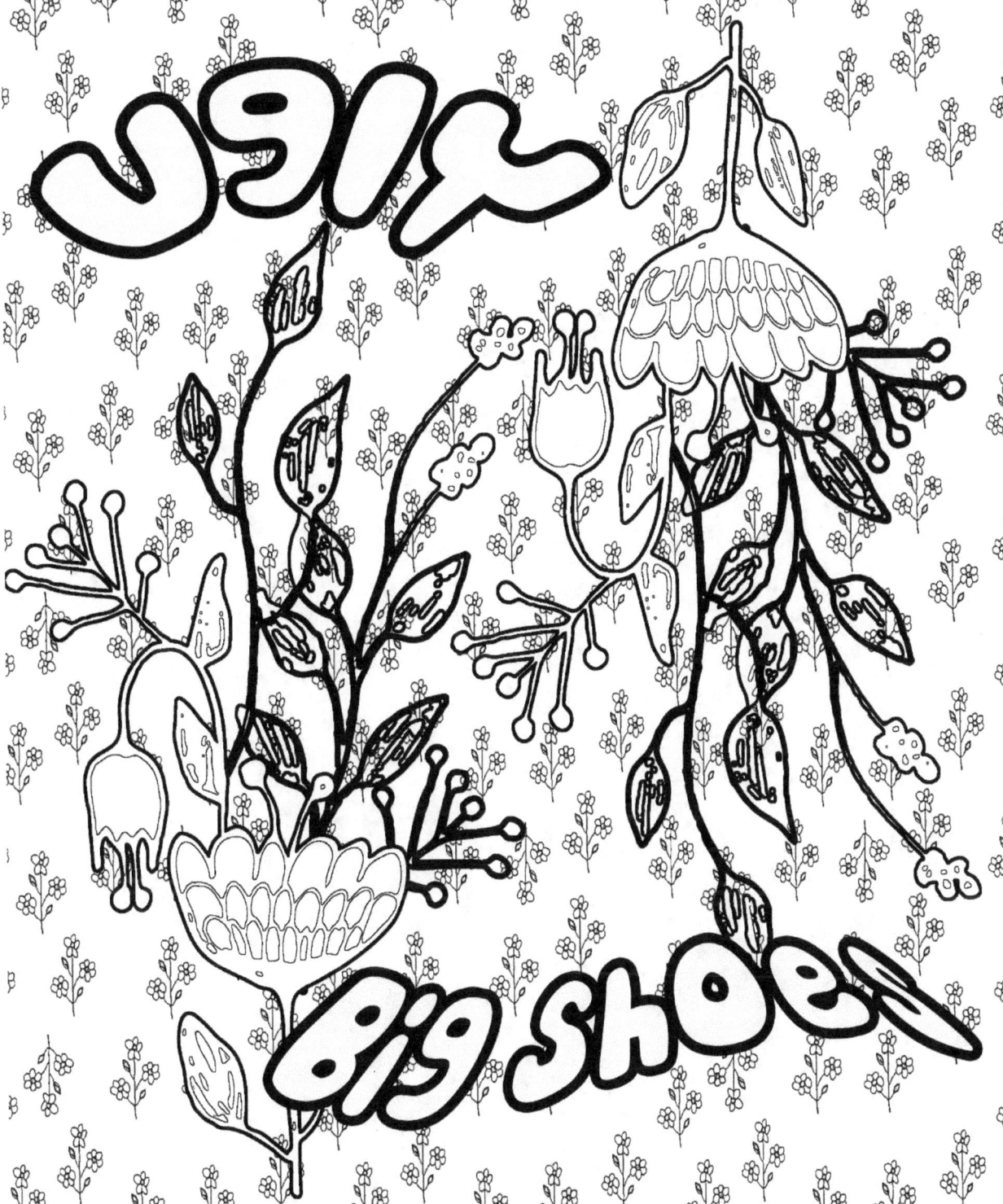

Douche Bag

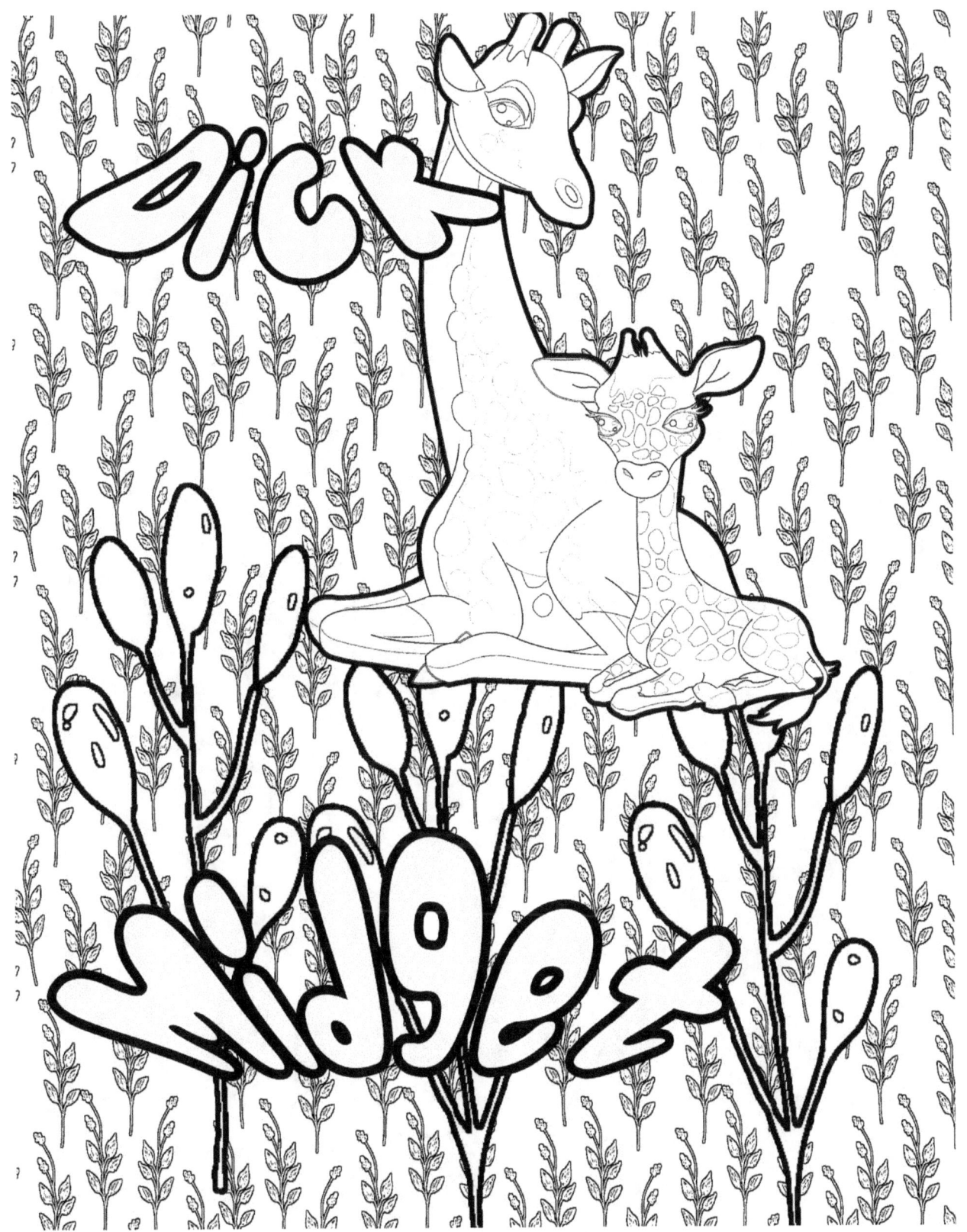

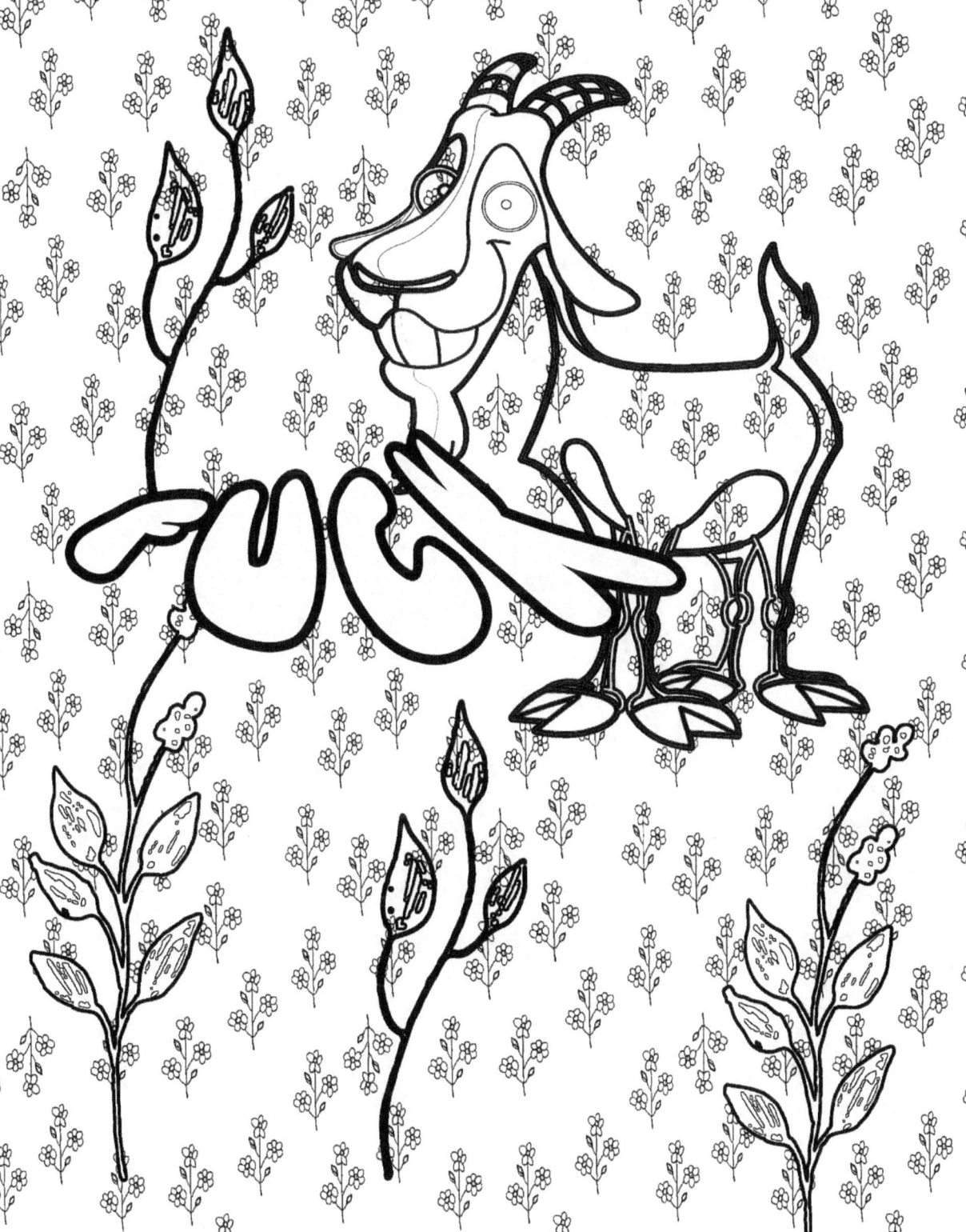

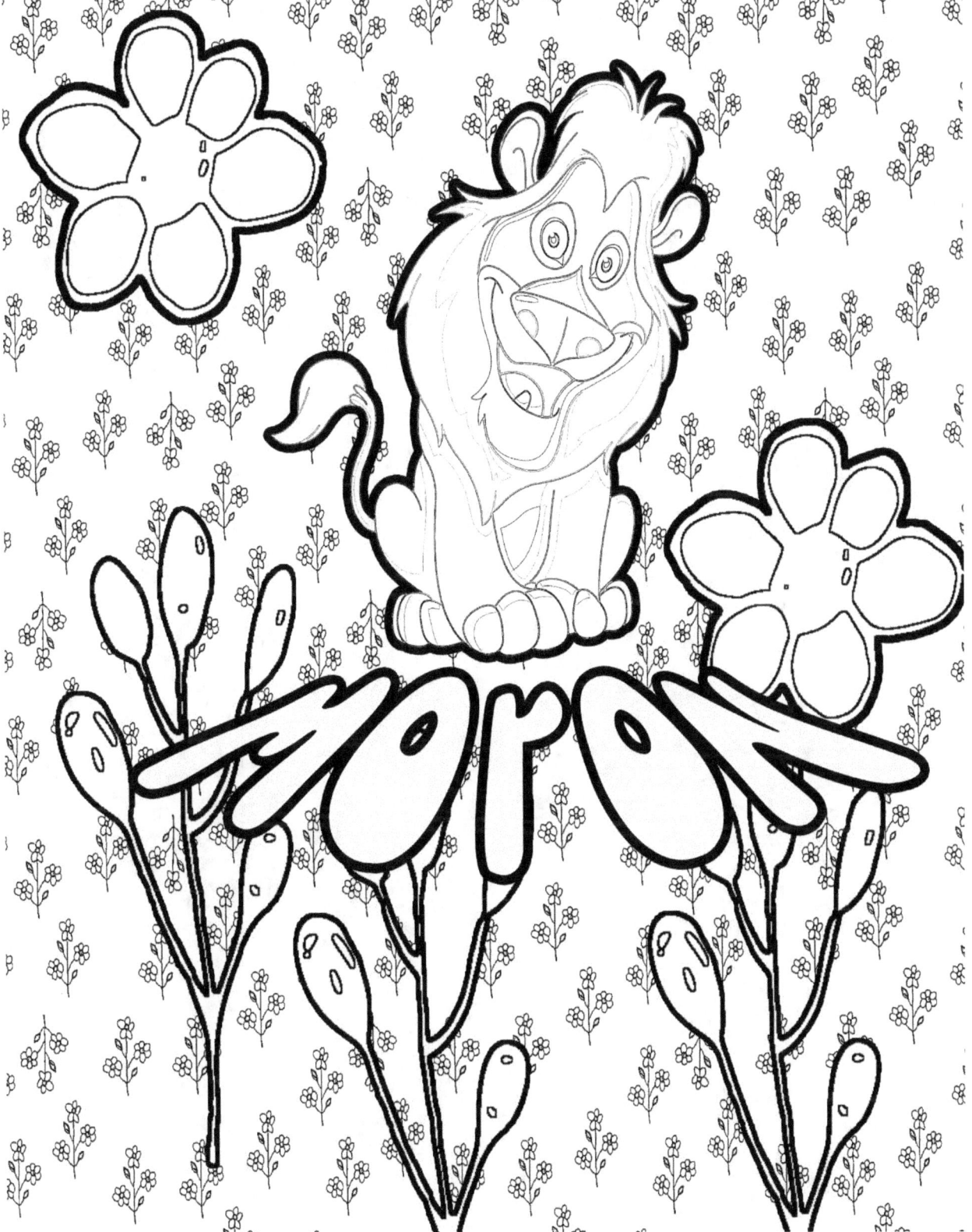

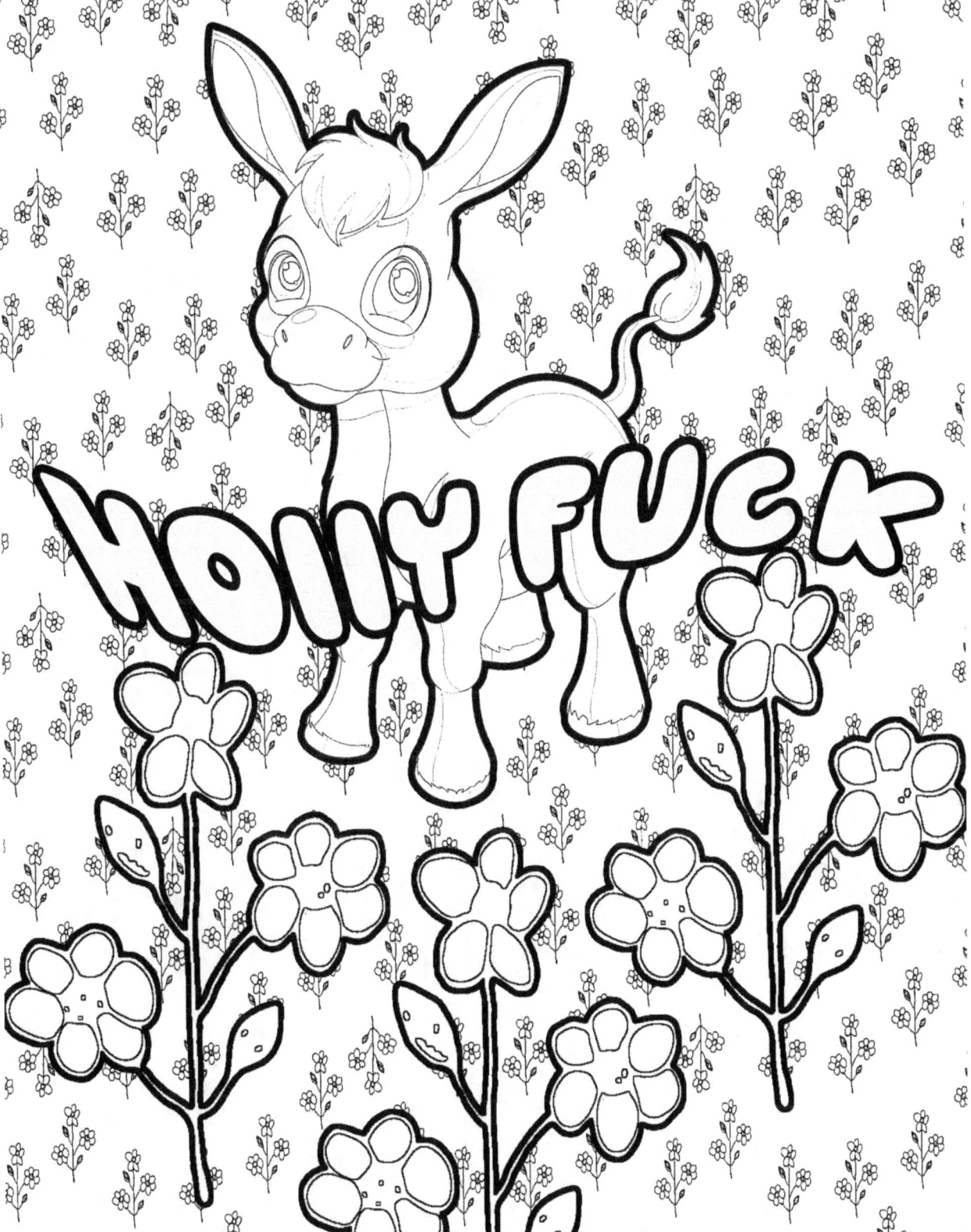

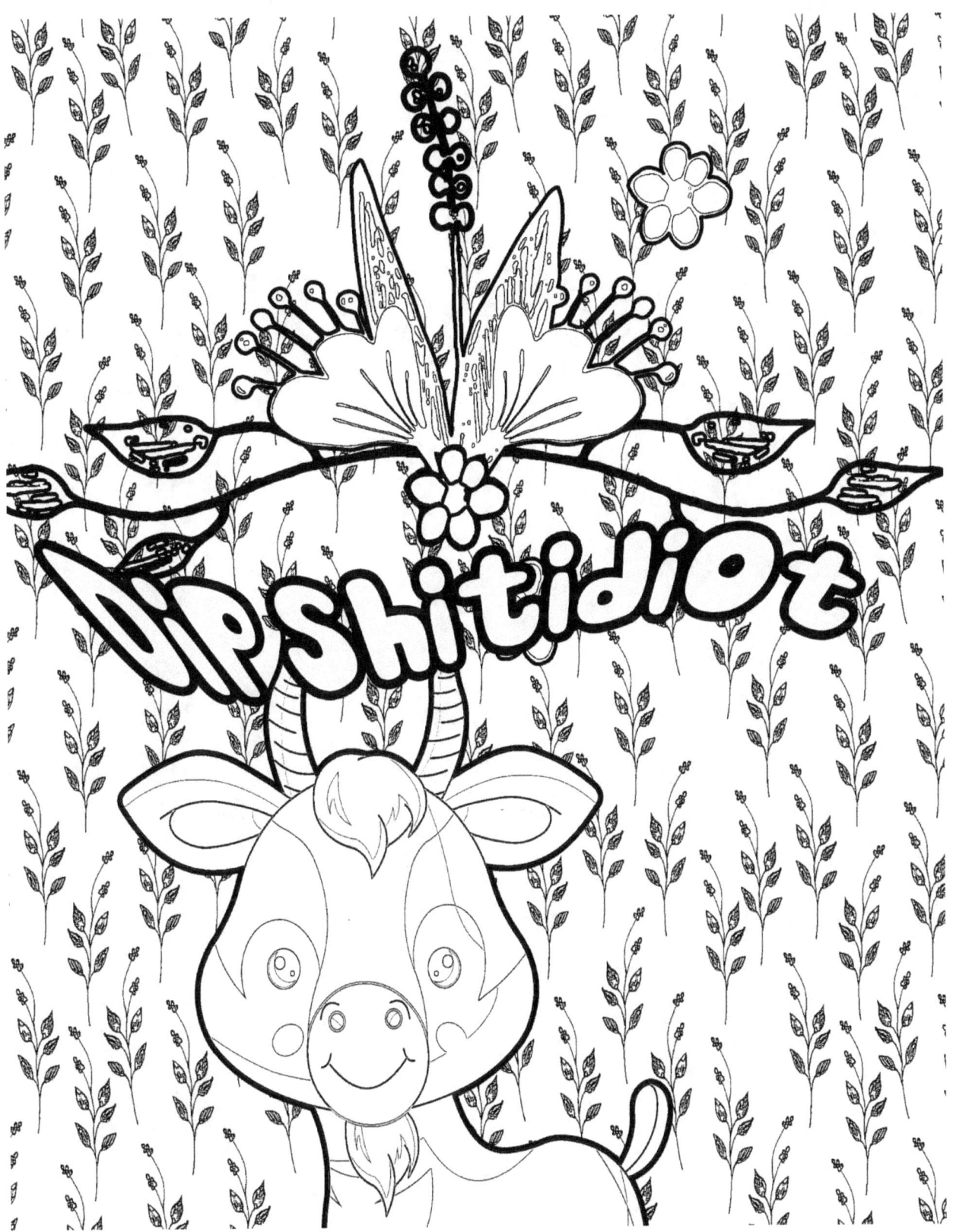

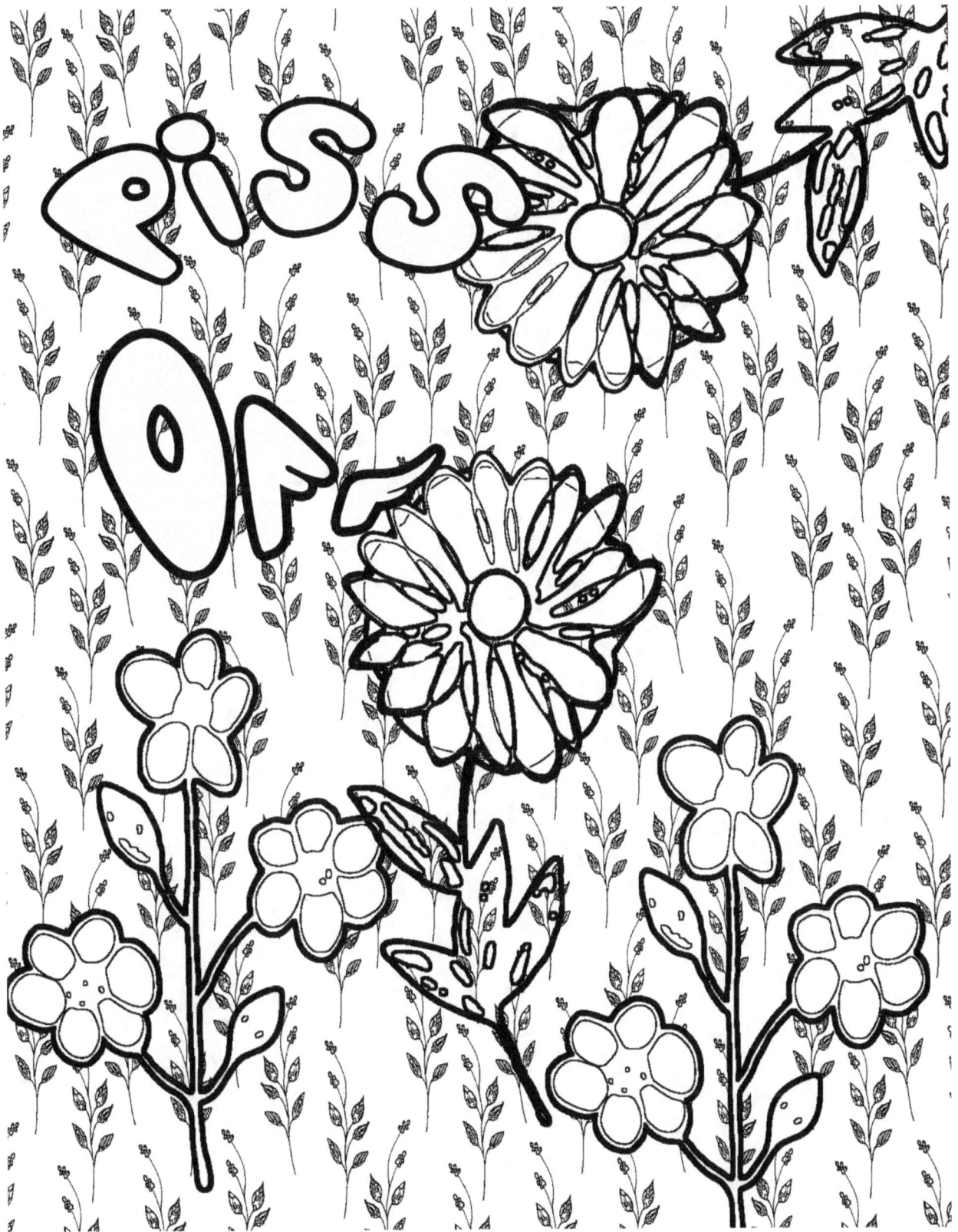

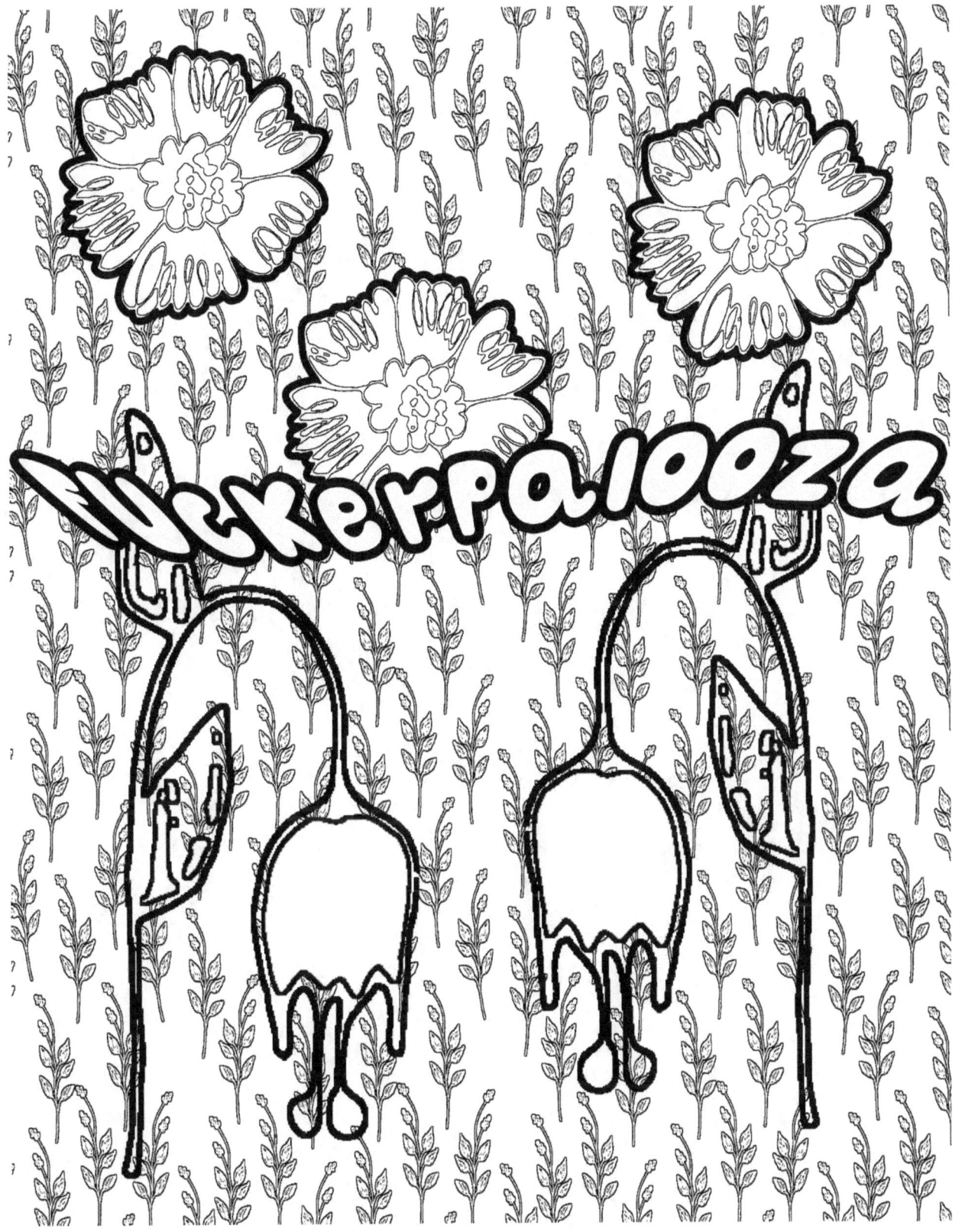

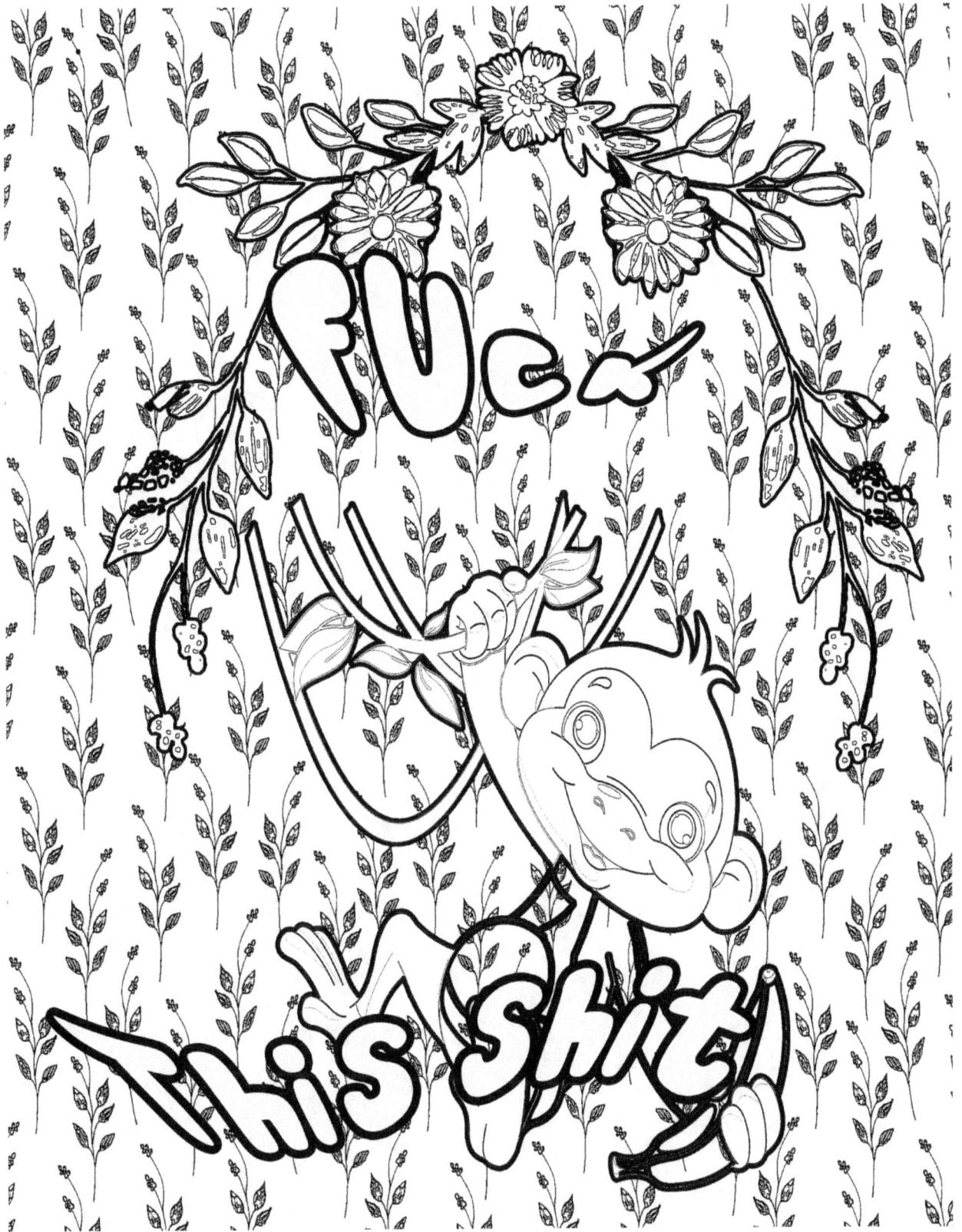

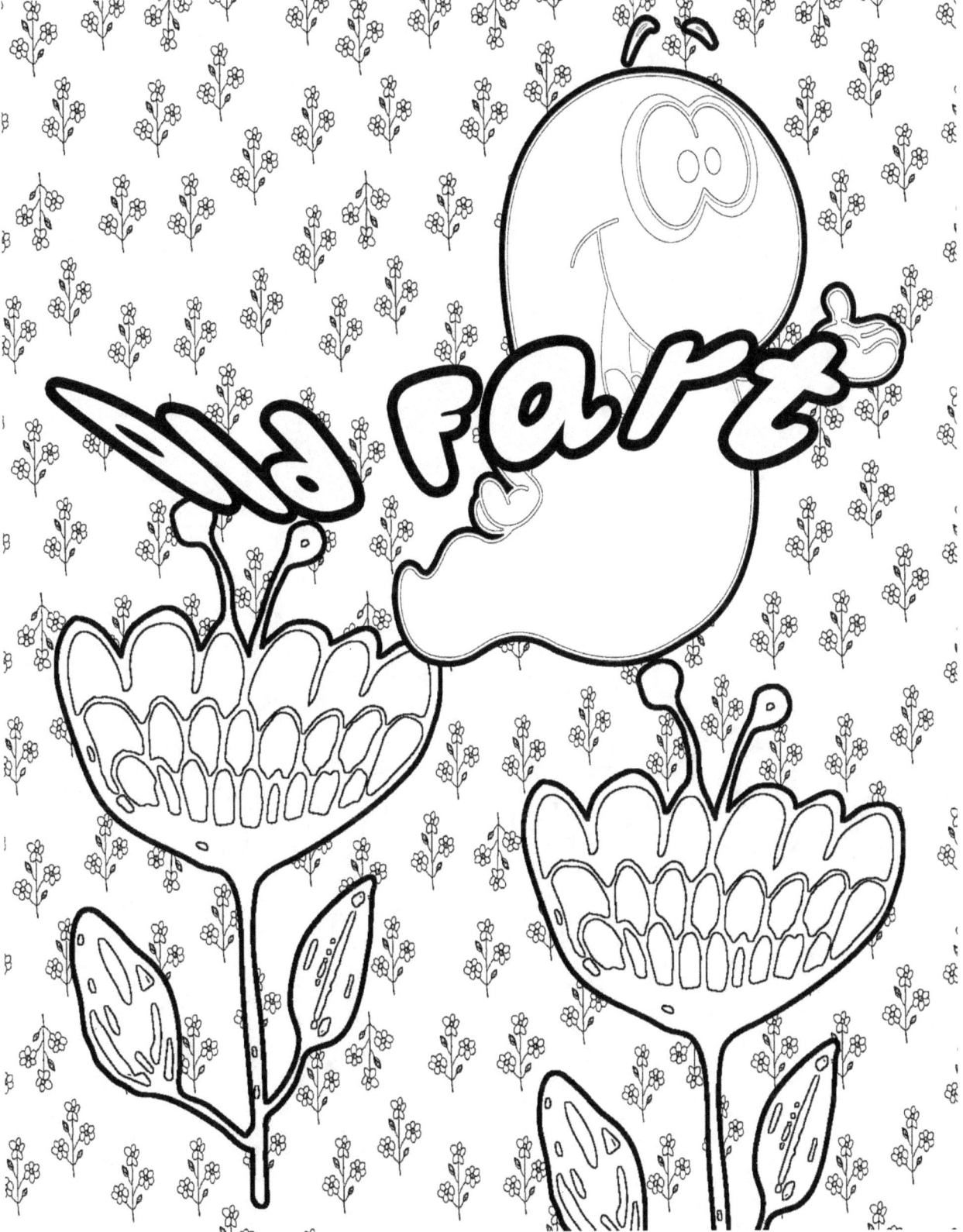

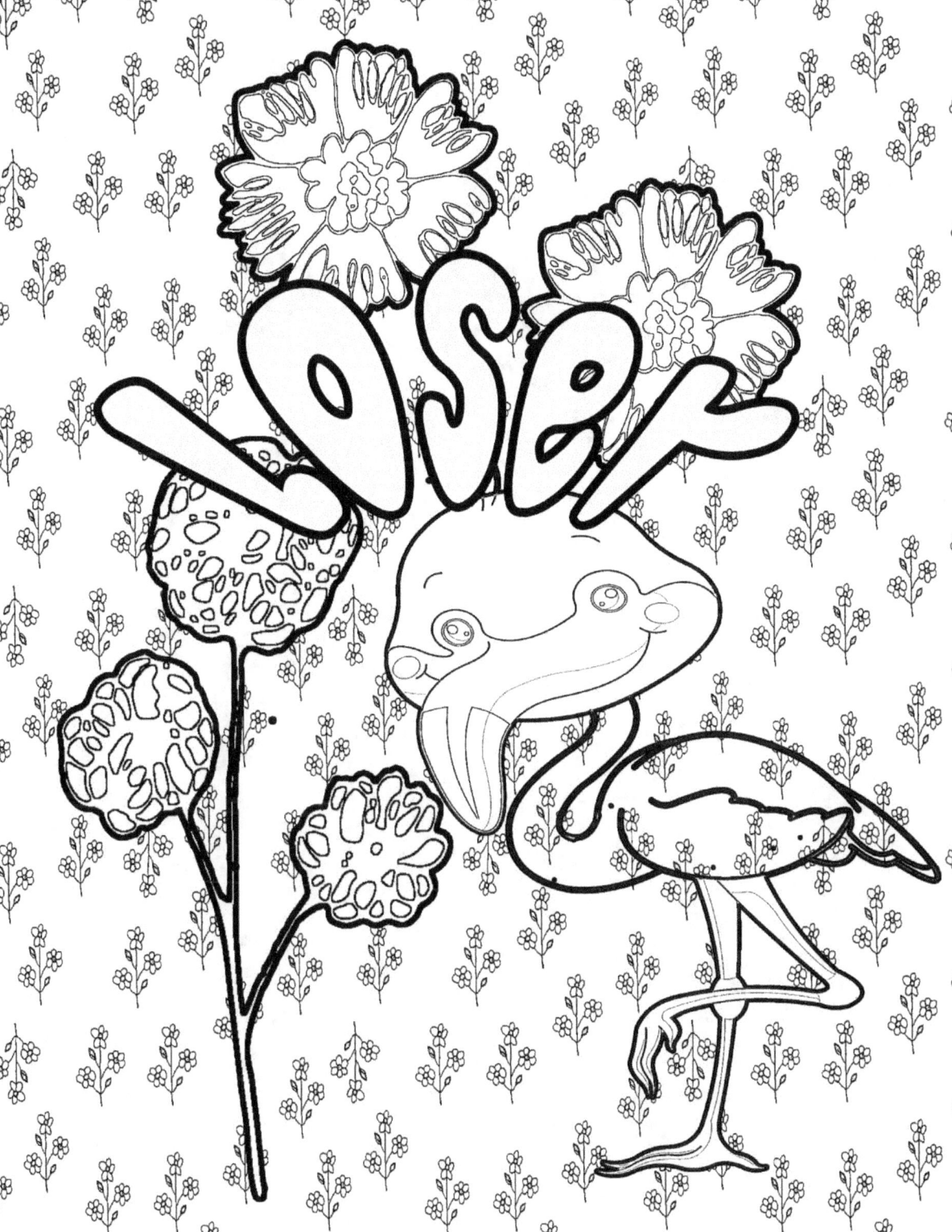

Note

www.ingramcontent.com/pod-product-compliance
Lightning Source LLC
Chambersburg PA
CBHW060601210526
45170CB00020BA/3004